# STAY COOL

## A Polar Bear's Guide to Life

**Images by Jonathan Chester**

**Words by Patrick Regan**

**Andrews McMeel Publishing, LLC**

Kansas City • Sydney • London

10 11 12 13 14 WKT 10 9 8 7 6 5 4 3 2 1

ISBN-13: 978-0-7407-9137-6
ISBN-10: 0-7407-9137-0

Library of Congress Control Number: 2009940828

www.andrewsmcmeel.com

**ATTENTION: SCHOOLS AND BUSINESSES**
Andrews McMeel books are available at quantity discounts with bulk purchase for educational, business, or sales promotional use. For information, please write to: Special Sales Department, Andrews McMeel Publishing, LLC, 1130 Walnut Street, Kansas City, Missouri 64106.

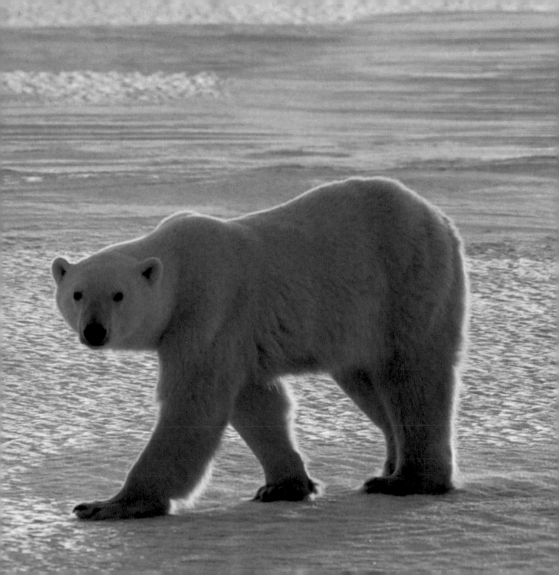

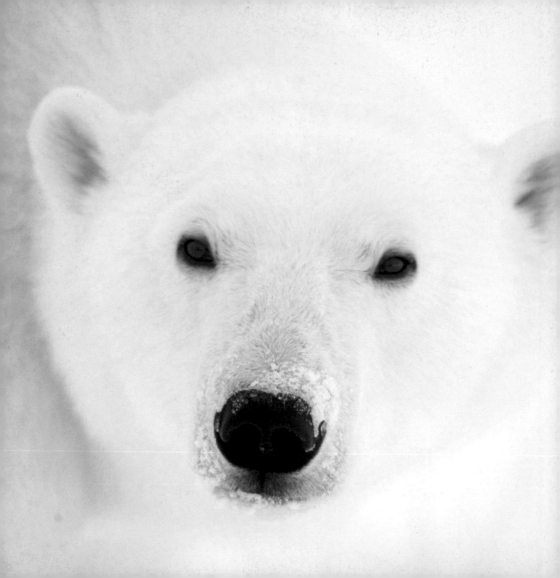

# What does it mean to be COOL?

Well, sitting at the top of the food chain for an entire ecosystem is pretty cool.

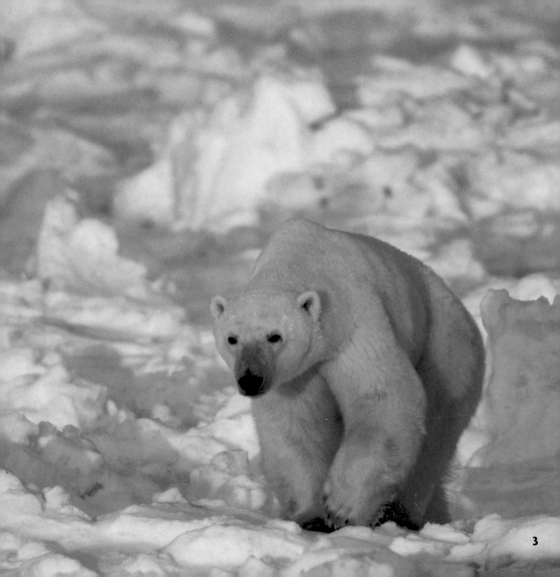

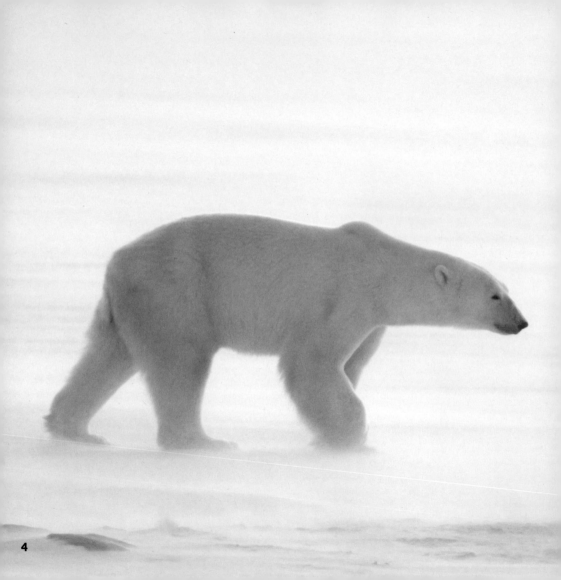

Being able to survive in the harshest of climates —that's cool, too.

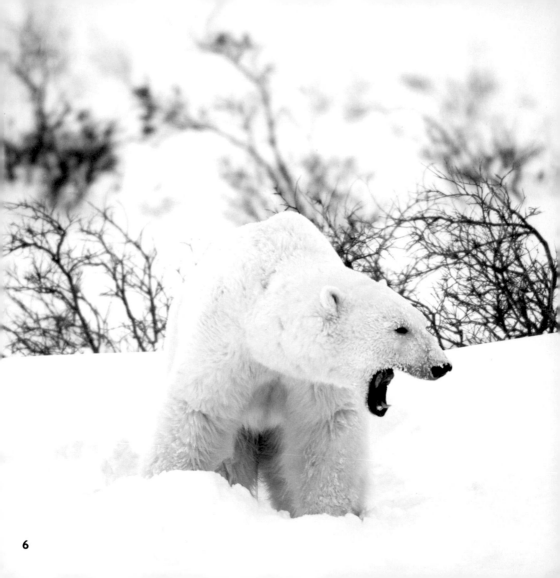

**Being mythologized, revered, feared . . .**

**all pretty COOL.**

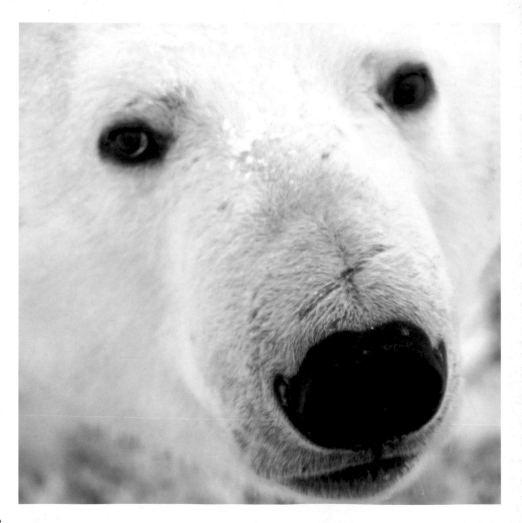

**But being cool isn't just about being the biggest and the baddest.**

**Being cool is about a lot of less obvious things, too.**

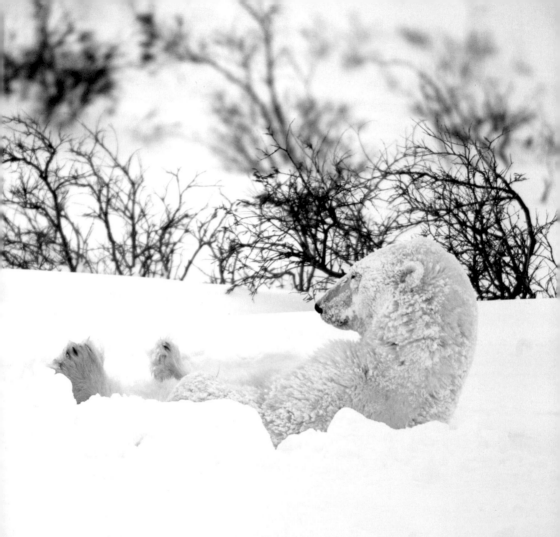

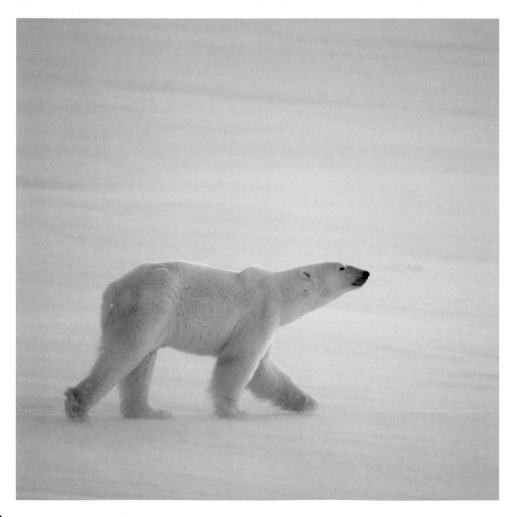

**Being cool is about the way you carry yourself.**

# It's about being in control . . .

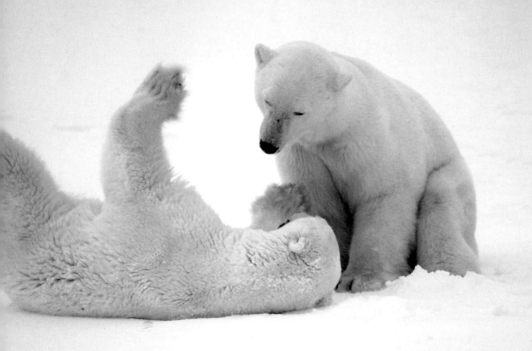

**or at least
appearing to be.**

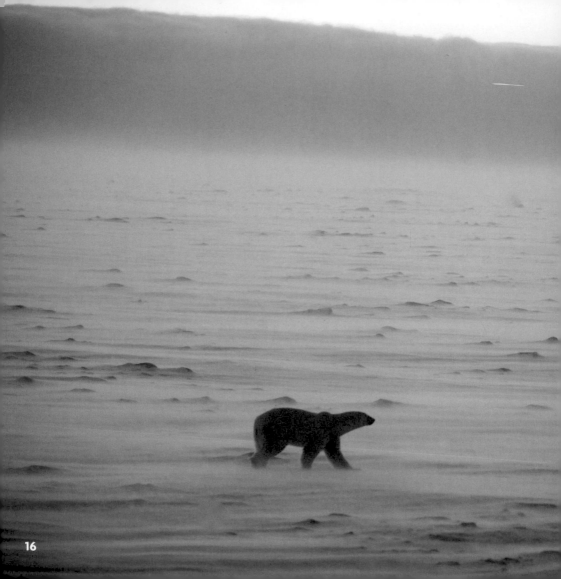

**Being COOL means living life in harmony with your environment,**

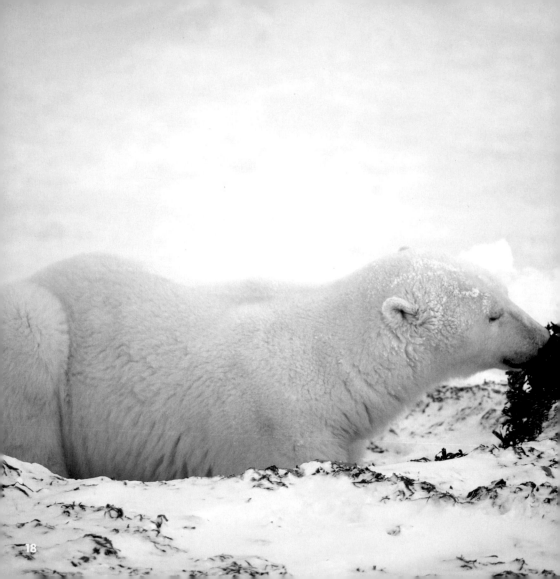

**and making the most of what's around you.**

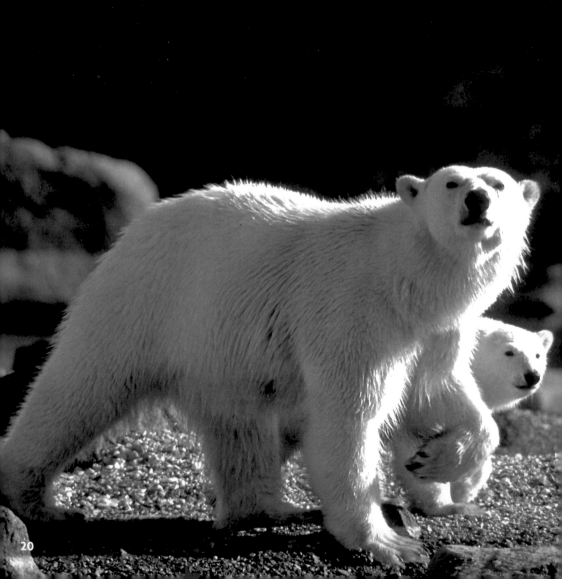

# It's about taking care of others,

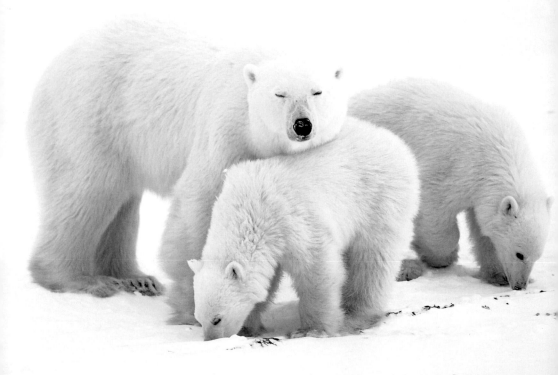

and knowing when to let others give you a little support, too.

**The surest way to be cool is to be happy with who you are.**

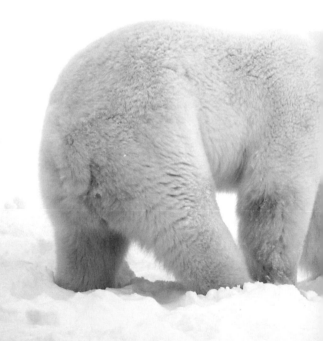

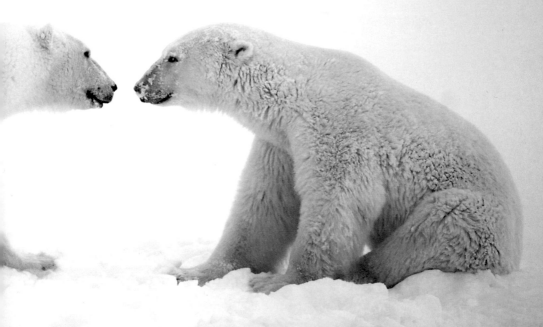

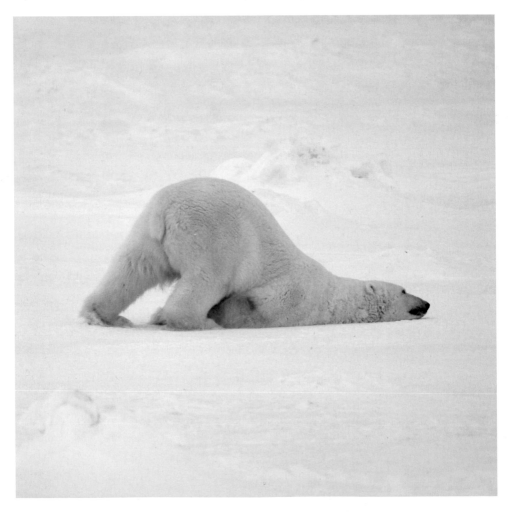

**That includes being comfortable with your body . . .**

**and content with
your unique talents.**
(After all, everybody's good
at something, and nobody's
good at everything.)

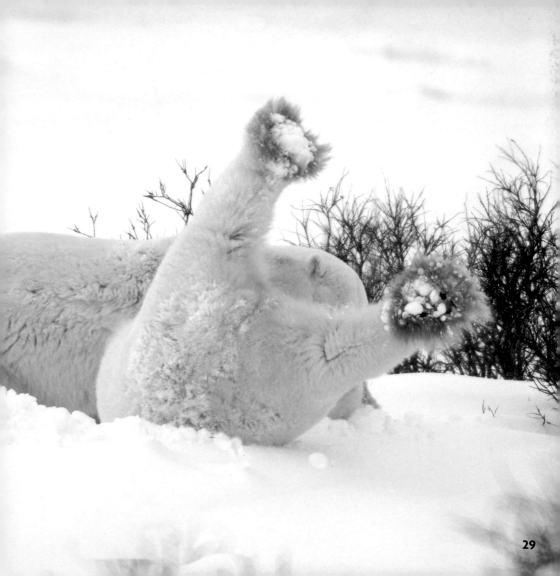

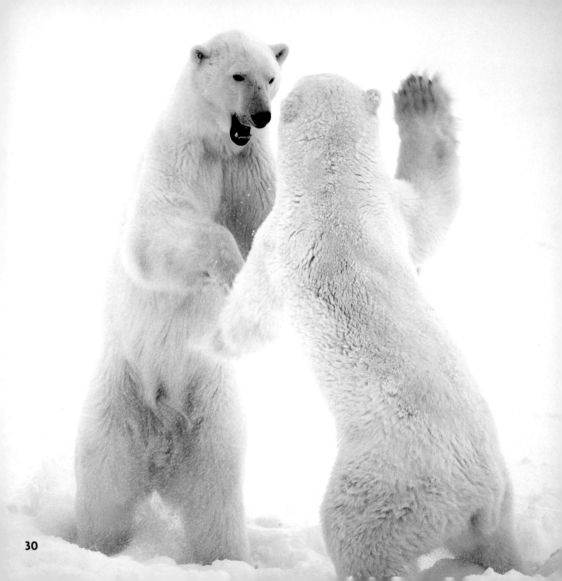

**Spending time with friends is cool . . .**

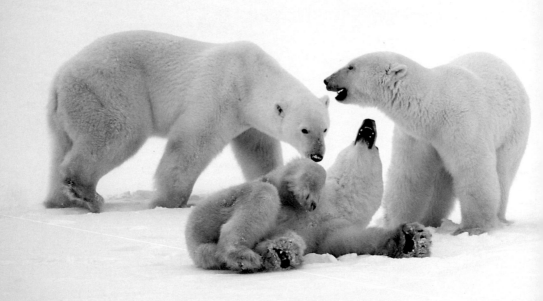

**even if you don't do much more than just hang around.**

**But it's also cool to enjoy your own company.**

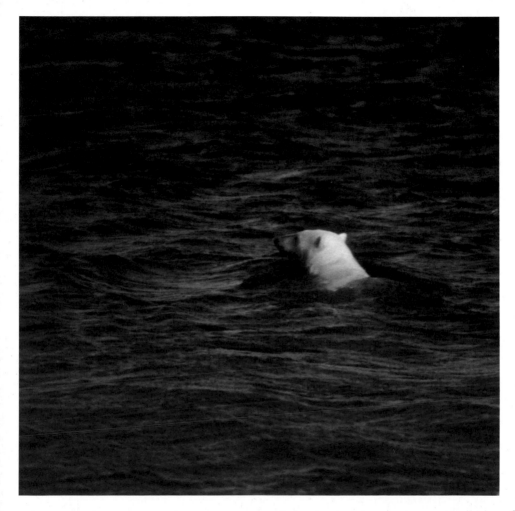

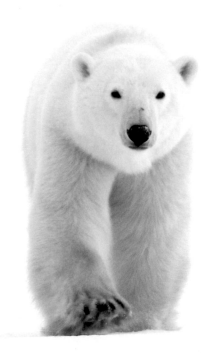

# Being **COOL** isn't always easy.

We all lose it
once in a while.

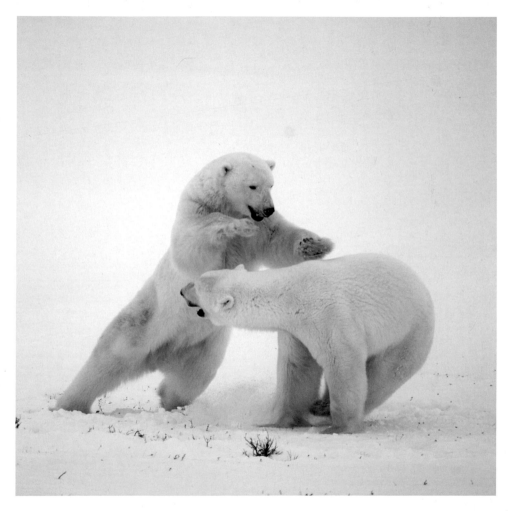

**When that happens,
it's best to let it all out,**

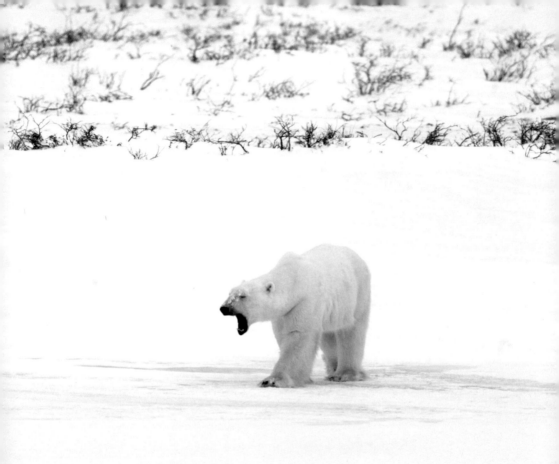

**take a deep breath,**

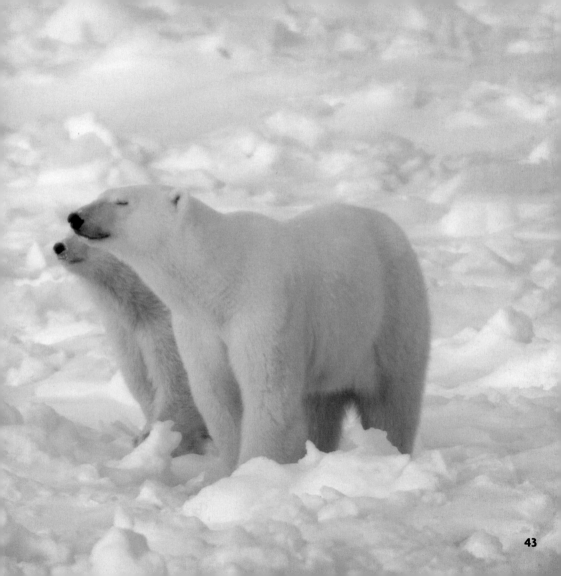

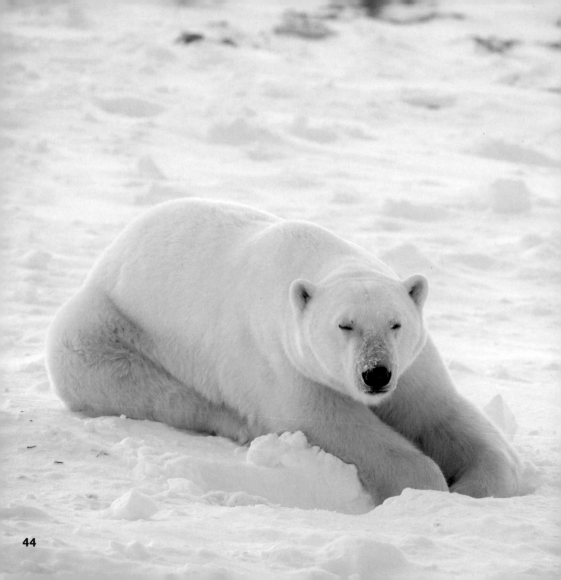

and remind yourself
that the only thing
you can truly control
is you—and your
reaction to what the
world throws at you.

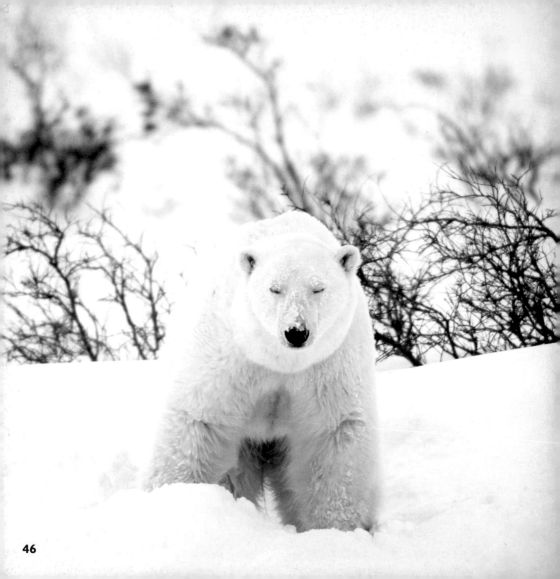

See, when you're cool, you don't let life's little aggravations get to you.

You make a fine art
of relaxation,

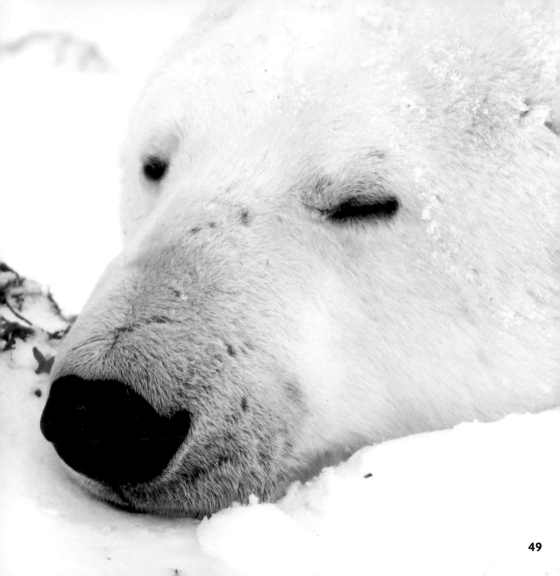

**and make simply enjoying life a priority.**

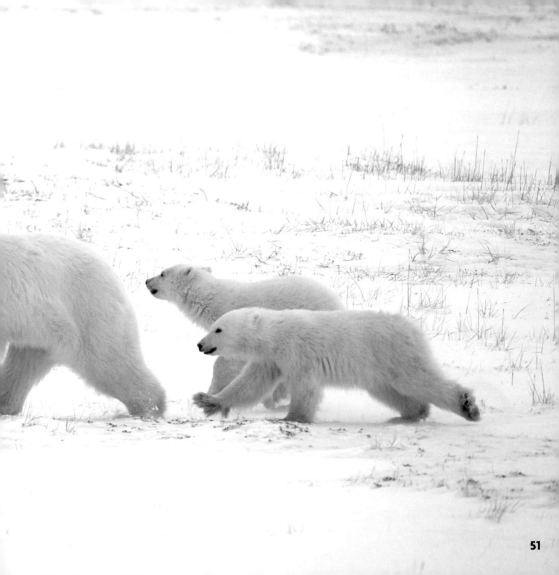

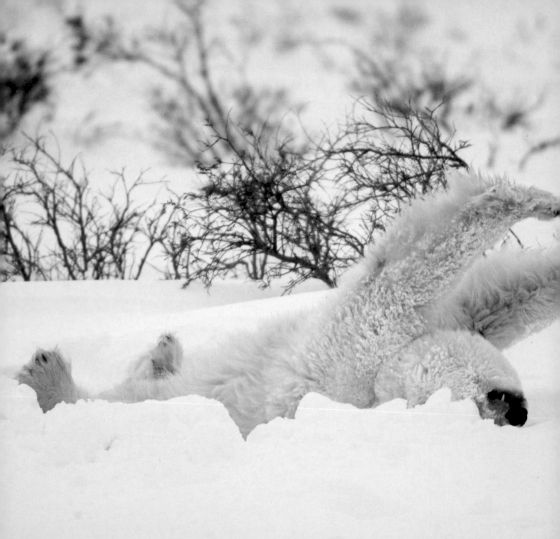

Incidentally, yoga works wonders for an overstressed mind and body.

And a little nap
now and then never
hurts either.

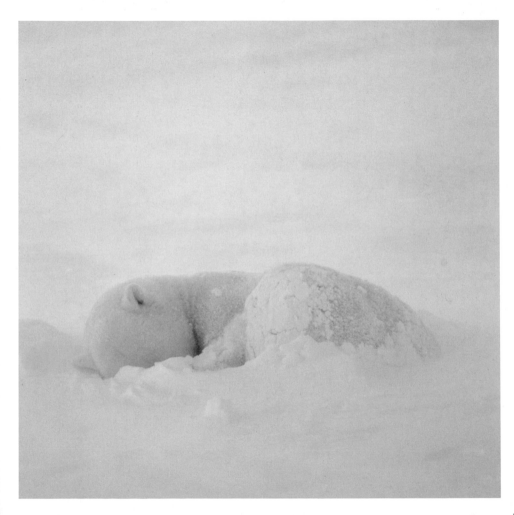

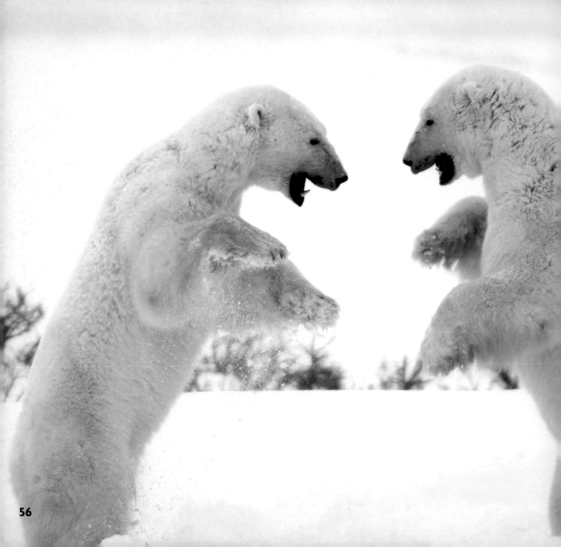

**Conflict is unavoidable in life.**

The trick is to give it just as much energy as it requires, and not an ounce more.

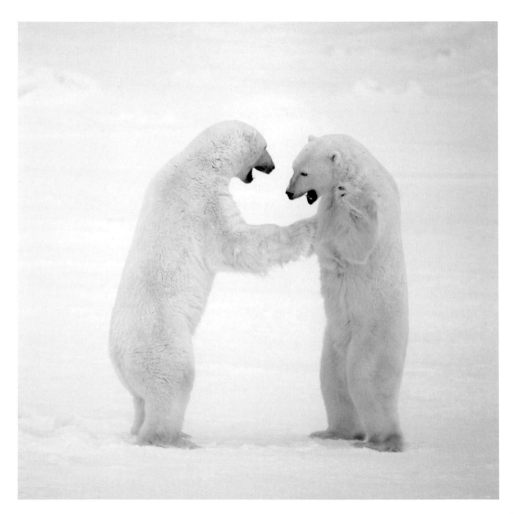

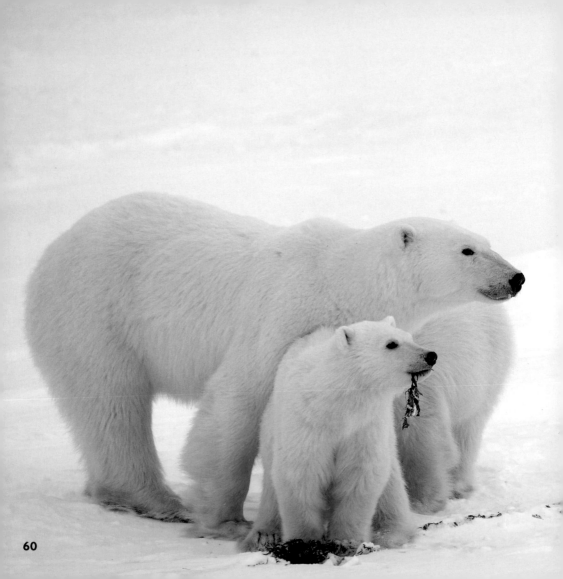

**Then you can get back
to the things that
really matter . . .**

# EXPLOR

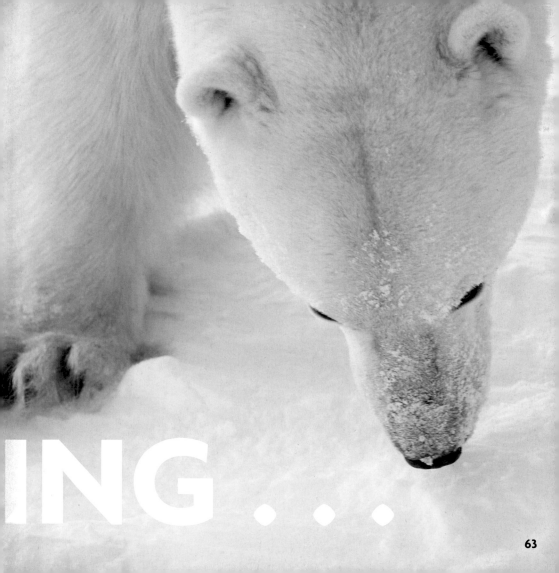

ING . . .

# PLAYING

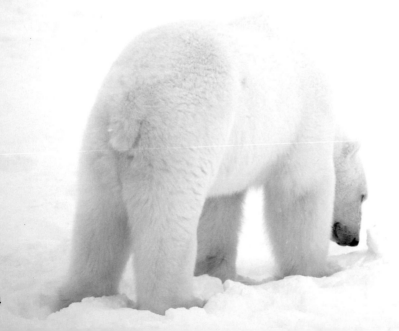

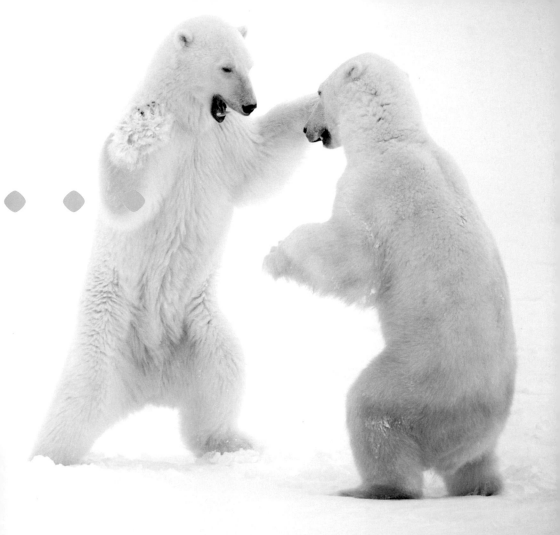

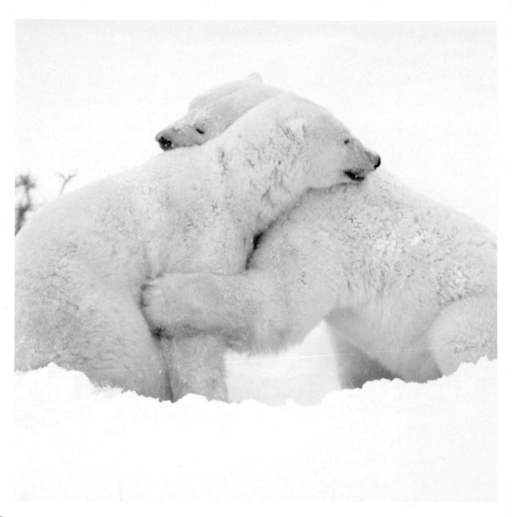

# LOVING . . .

DREAM

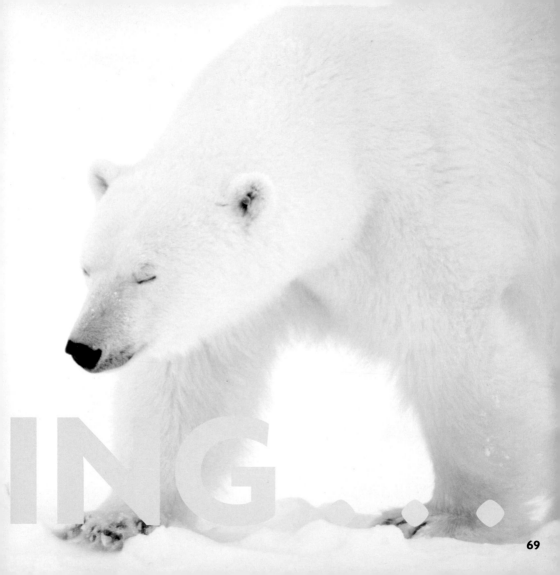

ING . . .

# Just keep one thing in mind.

At the twilight of a long day, it's not how you look or how you rank among your peers, or even what you've achieved that is most important.

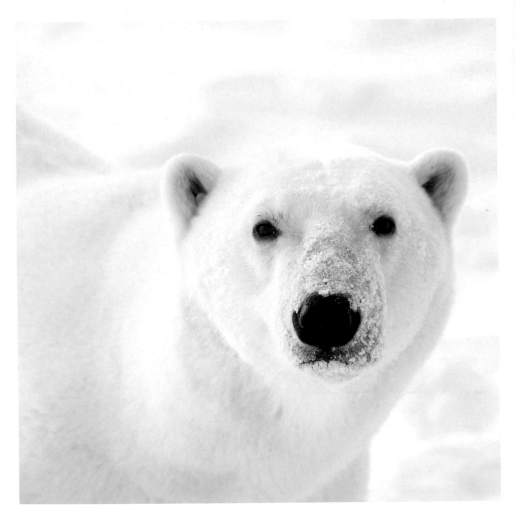

What really matters is that you've listened to that inner voice that tells you to be exactly who you are.

Because, really,
what could be

COOLER

than that?

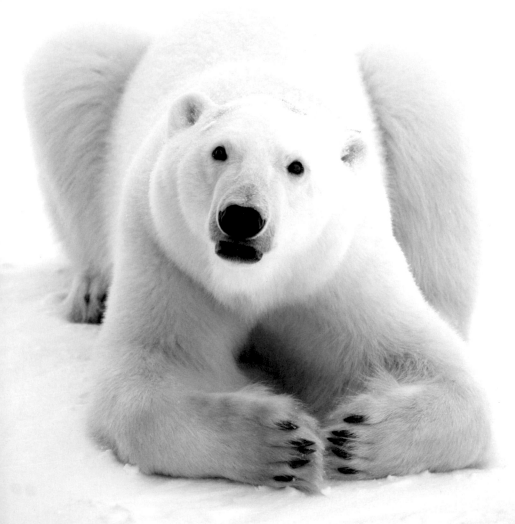

# IMAGE KEY

**A**ll images are of the one and only species of polar bear, *Ursus maritimus*, and unless indicated otherwise, were photographed at Cape Churchill, Wapusk National Park, on the shores of Hudson Bay in Manitoba, Canada.

**FRONT COVER**

Some 20,000 to 25,000 polar bears live in nineteen relatively discrete populations around the coastal areas of the high Arctic. The polar bear is the world's largest bear and the top predator in the circumpolar Arctic ecosystem.

**PAGE II**

The polar bear, also known as *nanuk*, was the Intuit people's most prized prey. Some called the bear "the great lonely roamer" and paid respect to *nanuk*'s soul (*tatkok*) by hanging its skin in an honored place in their igloo for several days.

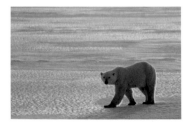

**PAGE IV**

About 60 percent of the world's polar bears live in Canada. The most southern and best-studied population in western Hudson Bay is showing the effects of global warming. Numbers have declined from 1,200 bears in 1987 to 935 in 2004.

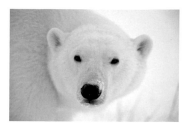

**PAGE VI**

The polar bear has become an important global symbol of the Arctic wilderness and rightly deserves its title as king of the Arctic. Humans are the only species that prey on the polar bear.

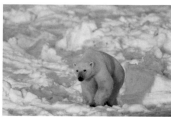

**PAGE 3**

Polar bears are carnivores that live most of their lives on or near Arctic sea ice, where they hunt for seals. The sea ice enables them to move between hunting and breeding areas. The ice advances and recedes dramatically with the seasons; this annual climatic cycle greatly influences the bears' movements and their ability to seek prey.

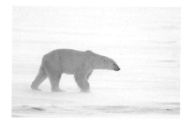

**PAGE 4**

The polar bear has a long neck, small ears, and an elongated head, adaptations that aid its sense of smell and help it to capture seals trying to slip through narrow holes in the ice.

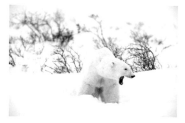

**PAGE 6**

In summer when there is little to no sea ice in the Hudson Bay region, polar bears typically move ashore and conserve energy in what is referred to as "walking hibernation." They can survive without eating for more than six months if they start out with enough body fat and get enough rest.

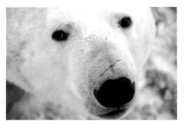

**PAGE 8**

Many polar bears have battle scars as a result of fights over the right to mate with a female. Males become sexually mature around five years of age, but they do not mate successfully until they are seven or eight and have grown strong and skillful enough to dominate their competitors.

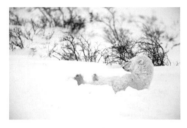

**PAGE 11**

Polar bears are completely covered in fur except for the tip of their noses and their footpads. Their thick winter coats with glossy guard hairs and dense underfur give them an efficient outer layer of insulation. This is complemented by a thick layer of fat (up to 4 inches [10 centimeters] thick) at the beginning of winter that helps to keep them comfortable in the snow and ice.

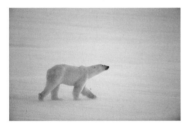

**PAGE 12**

Polar bears can maintain a steady pace of about 3.5 miles (5.5 kilometers) per hour and can continue at that speed for hours at a time. On a good surface, they can reach a speed of 20 miles (32 kilometers) per hour.

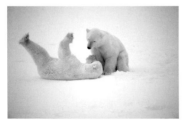

**PAGE 15**

Polar bears are solitary creatures for most of the year, with the exception of breeding pairs and mothers with cubs. The annual gathering of polar bears on the shores of Hudson Bay is unique because it is a large concentration of bears in a relatively small area. This leads to many encounters and social exchanges.

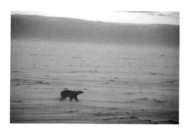

**PAGE 16**

Polar bears have overlapping home ranges that they do not defend. Adult females with cubs avoid interaction with adult males because of the potential predation by the males on the cubs.

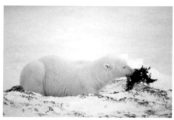

**PAGE 18**

Polar bears feed primarily on ringed seals. They will also eat other seal species and scavenge on carcasses of caribou, musk oxen, whales, and walruses. On the shores of Hudson Bay at the end of the summer, when their fat reserves are dwindling, many hungry bears can be seen foraging for algae.

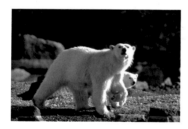

**PAGE 20**

Spitsbergen, Svalbard, Norway
A female polar bear usually produces only five litters in her lifetime. This is one of the lowest reproductive rates of any mammal. A polar bear cub takes solid food at about five months of age and is weaned at about twenty-six months of age, although this can vary greatly between regions.

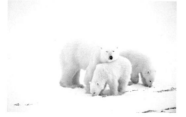

**PAGE 22**

The mortality rate for cubs in their first year of life ranges between 20 to 40 percent in different populations. Bear families usually break up when the cubs are about two and a half years old. Occasionally, cubs will remain with their mothers until they are three and a half. The most difficult time in a bear's life is its first year of independence.

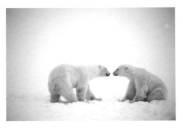

**PAGE 24**

Polar bear cubs drink their mother's milk for at least twenty months and depend totally on her for survival. The mother's success at hunting seals directly influences her own and her cubs' well-being. Orphaned cubs are unable to survive in the harsh Arctic environment.

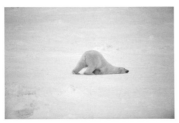

**PAGE 26**

Despite their massive size, polar bears are extremely agile and supple. Adult males usually weigh from 900 pounds (about 400 kilograms) to 1,300 pounds (about 600 kilograms), but can reach a weight of 1,700 pounds (about 800 kilograms), which is roughly the weight of a small car. They do not reach their maximum size until they are eight to ten years old. Adult females are about half the size of males and reach their maximum size by their fifth or sixth year.

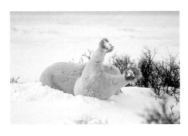

**PAGE 29**

The playfulness of the bears in the Churchill region is somewhat misleading. Although they often appear to be cuddly and cute, polar bears possess great strength and have a single-minded focus on finding, killing, and eating anything edible when they are starving.

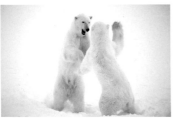

**PAGE 30**

In the final weeks of fall, many young male bears spend hours jousting on the shores of Hudson Bay while waiting for the surface of the Bay to freeze sufficiently so that they can begin their seal hunt. Polar bears have forty-two teeth, including long, sharp canines for piercing flesh and molars that have a scissorlike cutting arrangement.

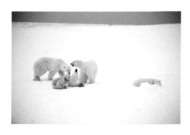

**PAGE 32**

It is unusual to see large numbers of polar bears in a small area. At the end of the summer, however, numerous bears congregate west of Churchill, especially at the very tip of Cape Churchill in Wapusk National Park. Here, sea ice forms earlier, giving the hungry bears a chance to begin hunting.

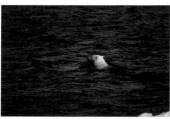

**PAGE 35**

Spitsbergen, Svalbard, Norway

The polar bear's scientific name is *Ursus maritimus* (sea bear), so named because it is the only marine bear. Although polar bears are excellent swimmers, they are unable to catch prey in the water. They use their large front paws as powerful oars while their rear paws act like rudders. They can keep their eyes open underwater and may remain submerged for over a minute.

**PAGE 36**

The word "Arctic" comes from the ancient Greek word *Arktikos*, or "country of the great bear." The Greeks named the region after the constellation Ursa Major, the Great Bear found in the north sky, even though they had no knowledge of the existence of the polar bear.

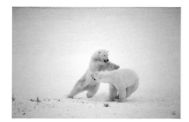

**PAGE 39**

Despite the obvious cost in terms of energy loss for these hungry bears, young males joust for hours in the fall. This play fighting strengthens them for future contests with each other for dominance and the opportunity to breed.

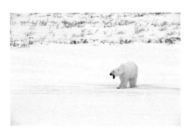

### PAGE 41

A polar bear wards off other bears with loud roars and deep growls when defending a food source. It lowers its head, pins back its ears, and hisses and snorts to show aggression. In response to stress, the polar bear makes a chuffing sound.

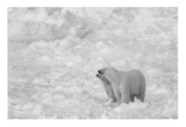

### PAGE 42

Polar bears, especially mothers and dependent cubs, hunt for newborn ring seals in April and May. Bears use their acute sense of smell to locate the seals' birth lairs underneath snowdrifts. The bears eat mainly the fat and the skin, leaving much of the meat for scavengers such as the arctic fox.

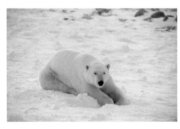

### PAGE 44

The polar bear, also called the ice bear, sea bear, and white bear, is known as *nanuuq*, *nanuq*, *nanook*, and *nanuk* by the Eskimos, *isbjørn* (Danish, Norwegian, and Swedish), *oso polar* (Spanish), *ours polaire* and *ours blanc* (French), and *eisbär* (German).

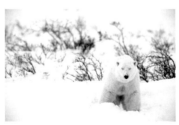

### PAGE 46

Polar bears are considered to be a relatively new species that evolved from the brown bear, *Ursus arctos*, millions of years ago. Today, brown bears, which also include grizzly bears, have been known to mate with polar bears and produce fertile offspring.

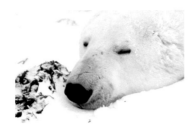

**PAGE 49**

Polar bears have an extremely keen sense of smell that enables them to detect seal breathing holes covered by up to 3 feet (1 meter) of snow and ice from more than a half mile (1 kilometer) away. It is believed that bears have hearing and eyesight similar to that of human beings.

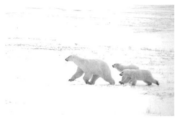

**PAGE 50**

Twins are most common for about two-thirds of the polar bear litters in all areas. Younger and older females often have only one cub, while two or three cubs may be born to females between the ages of eight and twenty.

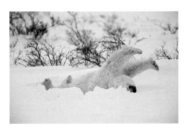

**PAGE 52**

The polar bear is well adapted to enduring in the Arctic, where winter temperatures of −50°F (−45°C) are not uncommon. Its full winter coat, complemented by a thick layer of blubber, protects the polar bear against the extreme cold. Its guard hairs also shed water easily; after a swim, polar bears can shake themselves dry like dogs do.

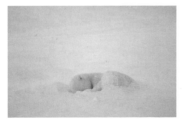

**PAGE 55**

Polar bears sleep seven to eight hours at a time, and they often take naps to help conserve energy. Another remarkable adaptation polar bears have developed is the ability to slow down their metabolism after seven to ten days of not eating at any time of the year, until food becomes available again.

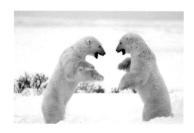

### PAGE 56

Although the polar bear's coat appears white, each individual hair is actually a clear, hollow tube. Some of the sun's rays bounce off of the fur, making the coat appear white during the summer months. During the summer, the polar bear gradually sheds its coat and grows a new one. By the following spring, the sun has caused the coat to turn yellowish brown. This color may also be due to staining from seal oils.

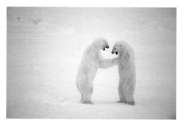

### PAGE 59

As the weather grows cooler on the shores of Hudson Bay in late fall, male polar bears spend hours sparring with one another until they both tire or one becomes dominant. Male bears circle one another cautiously, and these encounters often lead to physical contact. Each standing upright to a height of over 9 feet, the sparring bears are an impressive sight.

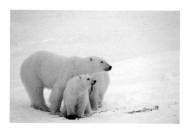

### PAGE 60

In October and November, pregnant female polar bears seek out dens on the sea ice or on the mainland. Usually two cubs are born in December or January. Young cubs are blind and hairless at birth, but they grow rapidly from their mother's rich milk and emerge from their dens in spring.

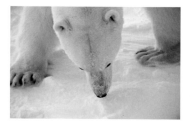

### PAGE 63

Scientists have estimated that a polar bear requires an average of forty-five ringed seals (or the equivalent) per year to thrive. Like polar bears, ringed seals are highly evolved to live and breed on sea ice. As the sea ice declines, so do the number of ringed seals and polar bears.

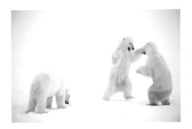

**PAGE 64**

Thousands of nature lovers flock to Churchill, Manitoba, every fall to observe polar bears in the wild. This is the single best location in the entire world to see the spectacular sparring behavior from the safety of a Tundra Buggy, a buslike vehicle with giant tires.

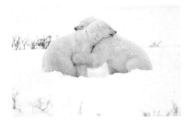

**PAGE 66**

Jousting bears often lock in a very real bear hug. Despite their massive size, they seldom draw blood or hurt each other in these lumbering play fights. All the same, bears have been known to have tantrums. After failing to catch a prey, polar bears have been observed throwing chunks of ice and kicking snow.

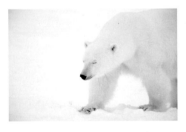

**PAGE 69**

Because polar bears are so well insulated with blubber and thick fur, they can overheat very quickly, even in subzero temperatures. To minimize this, they usually walk sedately and spend lots of time resting.

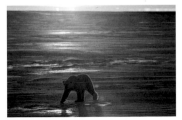

**PAGE 70**

Polar bears are prodigious roamers; they have been known to track and swim as far as 3,000 miles. However, most stay within their home range, which is typically a few hundred square miles.

**PAGE 72 AND BACK COVER**
In 1973, Canada, Norway, the United States, Denmark/ Greenland, and the Soviet Union signed the Agreement on the Conservation of Polar Bears, which called for restricted hunting, cooperative research, and the protection of the polar bears' habitat. In subsequent years, polar bear populations recovered dramatically.

**PAGE 75**
Polar bears have evolved long, catlike claws to better catch and hold fleeing prey, and to grip slippery ice when exiting the water. Their paws have fur between the pads, and the pads have dimples that give traction on the ice.

## Photographer's Note—Cape Churchill, Manitoba, Canada

Almost all the photographs in this book were taken at Cape Churchill in Manitoba, Canada. Churchill, the self-proclaimed "Polar Bear Capital of the World," has benefited from its proximity to areas where large numbers of bears gather in the fall while waiting for sea ice to form on Hudson Bay. Adventurers are able to see these incredible creatures from the relative comfort, safety, and security of Tundra Buggies. These oversized, rugged buses ride on giant tires to ensure their passengers are out of reach of the very hungry polar bears, with minimal impact on the fragile tundra ecosystem. Each November, at the end of the season, Frontiers North Adventures takes its Tundra Buggy Lodge to the legendary Cape Churchill in Wapusk National Park. In 2008, I was one of a lucky handful of enthusiasts who were able spend a week living among and photographing these magnificent bears . . . it was the assignment of a lifetime.

*Jonathan Chester*

# POLAR BEARS ON THIN ICE

**We have reached a critical crossroad. No matter what else we do, if we don't reduce greenhouse gas emissions, we won't have polar bears. We are faced with this crisis.**

*Dr. Steven C. Amstrup*
*Research Wildlife Biologist, USGS Alaska Science Center*

The polar bear is truly a magnificent creature. It is the largest species of bear and the largest land predator, and ranks at the very top of the Arctic food chain. When standing erect, a mature male is nearly 9 feet (3 meters) tall, and its mass is roughly twice that of a female bear. Over the past 100,000 years, these bears have evolved and adapted to the circumpolar Arctic sea ice. They are totally dependent on it for their diet, for movement, and for resting and reproduction.

Today, 20,000 to 25,000 wild polar bears are estimated to live across the vast Arctic region in nineteen discrete populations. Although polar bears are not an endangered species, their future is far from certain. In 2006, they were added to the International Union for Conservation of Nature (IUCN) Red List and classified as "vulnerable" based on the projected effect global warming will have on the Arctic sea ice, as determined by the IUCN Polar Bear Specialist Group. This body of biologists and climate scientists predicted the polar bear population will decline by more than 30 percent in the next thirty to fifty years. These figures are constantly being revised upward as new models are developed and studies are

reported. There is some suggestion that the entire species will disappear by the end of the twenty-first century.

In addition to the enormous effects of climate change detailed further in this essay, polar bears also face unprecedented threats to their well-being due to increased pollution, oil and gas development, and transport and hunting.

Because they are the top predators in the Arctic ecosystem, polar bears ingest dangerously high levels of pollutants that severely compromise their ability to reproduce, suppress their immune function, and disrupt their endocrine pathways. Polar bears ingest these pollutants by eating seals, which have been in turn contaminated by organic pollutants and toxic chemicals, such as heavy metals, PCBs, radioactive elements, and pesticides. The seals accumulate these from eating filter feeders, such as shellfish and crustaceans, lower down the food chain. The pollutants often enter the environment from more populated areas far away from the Arctic, but are then carried northward by winds and ocean currents.

Although the development and facilities associated with oil and gas exploration seem to be tolerated relatively well by bear populations, oil spills are a serious threat to bears and their seal prey through direct exposure.

The inevitable encroachment of human settlements, roads, and pipelines; the opening up of shipping lanes; and the growing tourist industry all result in more face-to-face confrontations between polar bears and humans. Although polar bears are curious and generally fearless, they do not typically attack humans unless a female bear is protecting her cubs or the bears are starving.

Occasionally bears are shot in self-defense, but in some parts of the Arctic, particularly in traditional communities, bears are still harvested as part of a subsistence lifestyle. Polar bear hunting is allowed for indigenous people up to a certain quota, but it is now believed that more recent limits are based on erroneous polar bear population estimates, and that the indigenous quotas do not take into consideration the effects of climate change on population reduction. In the Russian Arctic, there is little monitoring of hunting, and poaching is prevalent.

Global warming is affecting the ecology of the Arctic as well as all aspects of Arctic life. Studies have shown that overall sea ice cover in summer has declined by 15 to 20 percent over the past thirty years. Looking ahead, the U.S. geological survey models suggest that the sea ice cover near the continental shelf will decline by almost 70 percent during spring and summer toward the middle of the twenty-first century. Sea ice has been breaking up earlier in the spring and freezing later in the fall; as a result, the bears must fast for longer. Most experts now believe that the decline in Arctic sea ice

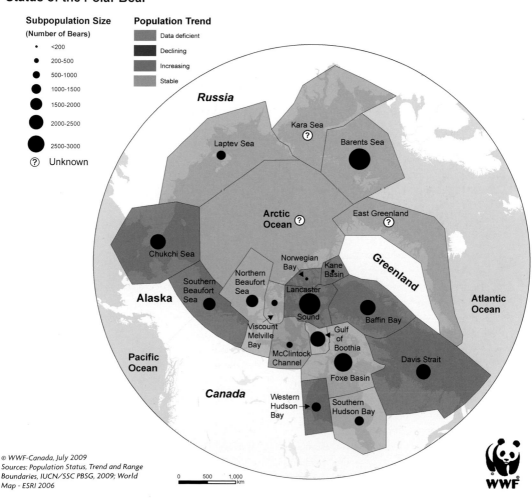

## Status of the Polar Bear

**Subpopulation Size**
(Number of Bears)

- ·   <200
- ●   200-500
- ●   500-1000
- ●   1000-1500
- ●   1500-2000
- ●   2000-2500
- ●   2500-3000
- (?)   Unknown

**Population Trend**

- Data deficient
- Declining
- Increasing
- Stable

*Russia*

Kara Sea (?)

Laptev Sea

Barents Sea

Arctic Ocean (?)

East Greenland (?)

Chukchi Sea

Norwegian Bay

*Greenland*

Kane Basin

Northern Beaufort Sea

Lancaster Sound

**Alaska**

Southern Beaufort Sea

Atlantic Ocean

Baffin Bay

Viscount Melville Bay

Gulf of Boothia

**Pacific Ocean**

McClintock Channel

Davis Strait

*Canada*

Foxe Basin

Western Hudson Bay

Southern Hudson Bay

© WWF-Canada, July 2009
Sources: Population Status, Trend and Range
Boundaries, IUCN/SSC PBSG, 2009; World
Map - ESRI 2006

0    500   1,000
km

**WWF**

could result in the loss of two-thirds of the polar bear population within the next fifty years because of increased death rates from drowning, cannibalism, and infant mortality from low birthweight. Of the nineteen recognized populations, studies have shown that eight are in decline.

As a result of this alarming situation, various governments around the world, especially those bordering the Arctic, have taken action individually and cooperatively, notably the United States, Canada, Greenland, Norway, and Russia. Some positive steps to manage hunting have recently been taken by Canada and Greenland, and there is increasing pressure to ban the trade in polar bear trophies, artifacts, claws, hides, and skulls.

Under pressure from both the public and nonprofit groups such as the Center for Biological Diversity, the U.S. government has taken additional steps to protect polar bears. In May 2008, the U.S. Department of the Interior listed polar bears as "threatened" under the Endangered Species Act because of decreasing sea ice. In October 2009, the Department of the Interior also announced plans to designate 128 million acres of Alaska's north coast as "critical habitat." This encompasses the entire range of several Alaskan bear populations numbering 2,500 individuals. Although this measure does not address the underlying problem of habitat loss due to global warming, it does represent a positive step.

These government steps all need popular support to be enacted. There are a number of organizations that are focused on educating people about the plight of polar bears by lobbying and presenting the necessary scientific information to legislators and policymakers. Polar Bears International is solely focused on education and funding scientific research. Other nongovernmental organizations such as the World Wildlife Fund and Defenders of Wildlife also have extensive campaigns focused on global warming, the Arctic, and polar bears.

So will polar bears sink into oblivion in the decades to come, only to be found in zoos, or will they survive to hunt and thrive in a renewed, icy Arctic? You can help by getting involved with the following organizations:

**POLAR BEARS INTERNATIONAL:**
http://www.polarbearsinternational.org/

**WORLD WILDLIFE FUND:**
http://www.worldwildlife.org/species/finder/polarbear/polarbear.html

**IUCN POLAR BEAR SPECIALIST GROUP:**
http://pbsg.npolar.no/en/index.html